William Hogarth

VISIONS IN PRINT

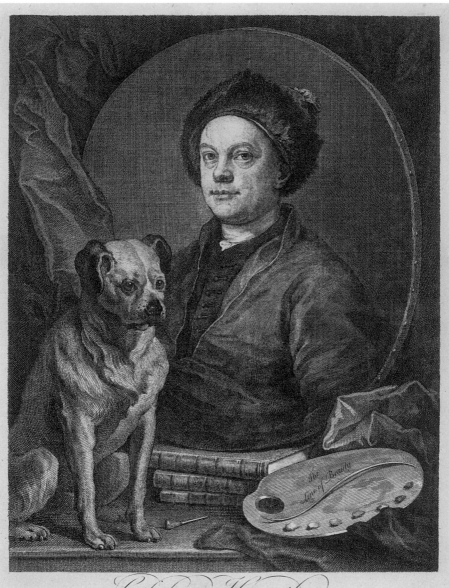

Gulielmus Hogarth.

Se ipse Pinxit et Sculpsit 1749.

William Hogarth

VISIONS IN PRINT

ALICE INSLEY

First published 2021 by order of the Tate Trustees
by Tate Publishing, a division of Tate Enterprises Ltd,
Millbank, London SW1P 4RG
www.tate.org.uk/publishing

A catalogue record for this book is available from the British Library
ISBN 978 1 84976 769 9

Distributed in the United States and Canada by ABRAMS, New York

Library of Congress Control Number applied for

Project Editor: Nicola Bion
Production: Juliette Dupire
Picture Researcher: Emma O'Neill
Designed by Caroline Johnston
Colour reproduction by DL Imaging, London
Printed and bound in Italy by Graphicom SPA

Front cover: William Hogarth, *Beer Street* 1751 (detail, see p.58)
Frontispiece: William Hogarth, *Gulielmus Hogarth* 1749

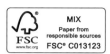

Contents

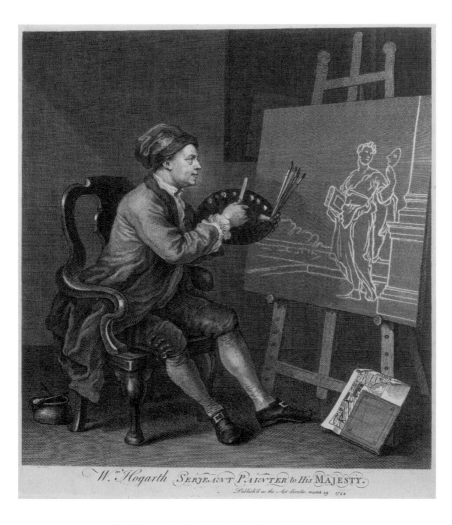

Self-Portrait Painting the Comic Muse 1758

Visions in Print

*It hath been thought a vast commendation of a painter
to say his figures seem to breathe; but surely it is a much
greater and nobler applause, that they appear to think.*[1]

<div align="right">Henry Fielding, 1742</div>

As the novelist Henry Fielding's words evocatively suggest, Hogarth's art not only brings people and places vividly to life but seems to cut through the surface appearances of society and of the city. Whether they depict polite gatherings or drunken parties, urbane pleasure gardens or notorious slums, sophisticated theatre performances or crowded, unruly fairs and streets, the immediacy and frankness of Hogarth's images appear, at least, to offer a piercing insight into the world around him. This distinct, 'Hogarthian' perspective – as it was known even in the artist's lifetime – is perhaps nowhere more apparent than in his prints, which have become synonymous with the artist's humorous and sometimes scathingly candid portrayal of eighteenth-century urban London. While today we might question some aspects of Hogarth's singular vision, these images continue to capture the imagination and to address us across the centuries.

Hogarth seems to have realised the lasting appeal of his prints too. Indeed, this book takes its inspiration from the bound collections of prints that he began to advertise as early as 1736. Always with an eye to self-promotion and the market, Hogarth no doubt recognised the impact such bound folios might have in creating a corpus of his graphic art, inviting people to understand his prints collectively, as a continuing endeavour. These folios proved highly popular,[2] and Hogarth recorded his pride that 'the prints which I had previously engraved were now

become a voluminous work, and circulated not only through England but over Europe'.[3]

It is revealing, then, that Hogarth chose his own image as the frontispiece for these volumes. From 1749, the collections opened with his self-portrait *Gulielmus Hogarth* [p.4].[4] Portraying himself as a picture within a picture, he confidently depicts the tools of his profession – his engraver's burin and palette – and asserts his aspirations. The inclusion of the 'line of beauty' on the painter's palette intriguingly alludes to his theoretical ideas about art,[5] and he positions himself in relation to the celebrated works of Shakespeare, Swift and Milton. His favourite pug, Trump, adds a wry humour, likely referring to the artist's own pugnacious personality.

In 1758, Hogarth produced another lively self-portrait, this time representing himself at work with palette, paintbrushes and palette knife in hand [p.8].[6] Picturing the very moment of putting paint to canvas, Hogarth vividly evokes the energy, creativity and skill of his art (the burin by his chair implying this equally applies to engraving), as well as its intellectualism: propped against the easel is a copy of Hogarth's artistic treatise *The Analysis of Beauty*, proudly indicating his credentials as an aesthetic theorist. Perhaps most tellingly though, the figure outlined on the canvas is the comic muse, both staking Hogarth's claim to pre-eminence in this field of art and elevating comedy's status by highlighting its classical roots and, crucially, its truth to nature.[7] In both these instances, Hogarth was clearly crafting his public image. That this was achieved through print, and in his collected works, speaks to how this was – and remains today – intertwined with his identity as a graphic artist.

This is perhaps unsurprising. Hogarth began his career as an apprentice to the silver-plate engraver Ellis Gamble in 1714. His upbringing had been precarious as his father struggled to get by, first as a schoolmaster and then as the proprietor of a London coffee house.

The failure of this venture led to his arrest for debt in the winter of 1707, forcing the whole family to live in the debtor's lodgings near Fleet Street Prison for the next four years. His father's last great scheme, to compile an ambitious Latin dictionary, proved just as unsuccessful and Hogarth blamed his father's death upon his disappointment and the exploitation of publishers and booksellers. As Hogarth later recalled, he had no option but to manage for himself, and he chose the more secure route of apprenticeship in a luxury trade.[8] But he soon grew bored of the repetitive and painstaking work of engraving heraldic and decorative patterns on plates, forks, spoons and other silverwares, and set his sights instead on copperplate engraving. As well as offering greater pictorial possibilities – like book illustrations, shop cards and designs after celebrated paintings – this was also a matter of status: while still widely classed as a skilled craft, copperplate engraving was at least deemed less mundane.

Breaking his apprenticeship early, Hogarth struck out as an independent engraver in spring 1720. Determined to carve out his place in the crowded print world, he quickly took up the emerging and distinctly modern genre of graphic satire.[9] Hogarth's skill, inventiveness and political edge was immediately apparent in *The South Sea Scheme* [p.20], a scathing comment on the greed and folly that had led so many of the population to invest in the South Sea Company and its multitude of improbable off-shoot companies, with disastrous consequences when the bubble inevitably burst that summer. Here, he opens speculation of all kinds to ridicule, with sex workers, clergyman and noblemen alike all shown playing on the wheel of fortune. Though perhaps less biting, the later *Cunicularii* is just as topical: it depicts the notorious Mary Toft and mocks the previously well-regarded doctors duped into believing she was giving birth to rabbits [p.21].

It was also at this time that Hogarth enrolled at the new painting academy at St Martin's Lane, run by John Vanderbank and

the Frenchman Louis Chéron. While this provided an important opportunity to study from life models, it is perhaps more notable for the cosmopolitan social and artistic circles it opened up for Hogarth, and which remained important throughout his career. In 1724 Hogarth also began attending Sir James Thornhill's academy in Covent Garden. As well as bringing him into the sphere of the foremost British painter of the day, this also led to his relationship and later elopement with Thornhill's daughter, Jane. Although Thornhill was reputedly displeased at Jane's marriage to an as yet 'obscure' artist,[10] this description does not quite do Hogarth justice. For he was, by this time, making a name for himself as a painter of conversation pieces (small-scale, generally polite, group portraits) – so much so that his 'daily success' and rapid rise in reputation were remarked upon.[11]

But it was *A Harlot's Progress* that really captured people's imagination and launched Hogarth into fame. While the paintings had been causing a stir among those visiting his studio,[12] it was the series of six prints published in April 1732 that were widely bought and circulated, even inspiring theatre performances and reproductions on ceramics and fans [pp.22–7]. The series tells the fateful story of Moll Hackabout, a young country girl new to London and soon enticed into sex work. At first she enjoys a luxurious lifestyle as mistress to a wealthy Jewish merchant (highly stereotyped by Hogarth), but soon – presumably because her other lovers are discovered (one of them escapes unnoticed in scene two) – she falls on harder times, her health declining from venereal disease, until ultimately she suffers a lonely death. These 'modern moral subjects',[13] as Hogarth called them, were entirely novel: satirising eighteenth-century society's hypocrisy, selfishness and brutality, *A Harlot's Progress* played upon the contemporary fear of and fascination with sex workers, drew on current affairs and is peppered with recognisable portraits;[14] it found its subject and setting in urban London, and revealed Hogarth's habit of memorising

– sometimes by means of tiny sketches he made on his thumbnail – anything striking that caught his eye as he moved through the city.[15]

The extraordinary popularity of *A Harlot's Progress*, however, also prompted a plethora of pirated copies. Uniting with his fellow artists, Hogarth responded with a campaign against such practices, which culminated in the Engravers' Copyright Act of 1735 (also known as 'Hogarth's Act'). It was not until the act passed into law that he published his second modern moral series, *A Rake's Progress* [pp.30–7].[16] The eight pictures show the downfall of Tom Rakewell who, after inheriting a fortune from his miserly father, rapidly spends all his money on aping the ways of the aristocracy and in debauchery. He finds brief respite from disaster through marriage to an old but wealthy bride, but nevertheless ends up in debtors prison and, finally, in Bedlam. Hogarth again rooted this story of masculine waywardness in modern urban life, depicting the temptations of the city and playing upon contemporary preoccupations, satirising self-interest, self-delusion and the shifting social classes.

Over the following years Hogarth continued to cultivate his persona as a roving satirist,[17] alighting on subjects that reflected the chaos, noise and vitality of modern urban life and which perhaps, to our eyes today, suggest the faultlines within this society. Hogarth's highly popular *A Midnight Modern Conversation*, for example, while at first glance a jocular image of men misbehaving, reveals upon closer inspection the privileged position of these white men, and the wealth and material riches that were all underpinned by Britain's colonialist and exploitative global empire [p.29].[18]

It is small wonder then that Hogarth earned a reputation as unique 'in his way'.[19] But it should not be forgotten that in both his self-portraits he took great pains to present himself as a painter. To Hogarth painting was aspirational, representing respectability and high art, as opposed to what he, and many contemporaries, felt was the lowly labour of

engraving.[20] Consequently, while he was still prolific as a graphic artist, from the mid 1730s he made a concerted effort to signal his painterly ambitions and his desire to raise the status of British art. Not only was he instrumental in founding a new art academy in St Martin's Lane in 1735 – which soon became the artistic epicentre of the capital – he also increasingly looked to high-profile public commissions. The first of these was for St Bartholomew's Hospital; Hogarth even offered to work for nothing to guarantee himself the opportunity to demonstrate his powers as a history painter, then considered the highest branch of painting, and to outdo a foreign rival.[21] Following this, he took a far more sustained and active role in the Foundling Hospital, becoming a governor and orchestrating its decoration so that it became a kind of public exhibition space.[22] He even rigged a lottery through which print subscribers could enter for a chance to win his painting, *The March to Finchley*, ensuring that it instead went on display at the Foundling Hospital [p.57]. All the while, he continued to run a successful portrait practice among the urban elite, which, in such images as *Garrick in the Character of Richard III* [p.54], reveal his social connections, his ability to convey character and psychology, and his sense of theatre; he would later declare 'my picture is my stage, and men and women my players'.[23]

In 1743, with his fame at its peak, Hogarth began advertising his next series, 'representing a Variety of *Modern Occurrences* in *High-Life*, and called Marriage A-La-Mode' [pp.48–53].[24] Unlike his earlier 'Progresses', this was to be engraved by the best masters from Paris, immediately announcing the sophistication and luxuriousness of the prints.[25] This cleverly increased their aesthetic appeal, while both speaking to the narrative and being parodied by it: for, in satirising high society's adoption of foreign fashions, manners and goods – none more so than those of the French – Hogarth implied that these luxuries and tastes were detrimental to English society and values.[26] The moral decline of *Marriage A-la-Mode*'s young couple is constantly

visualised in terms of luxury and excess, particularly sexual profligacy: in Plate 2, *The Tête à Tête*, for example, they are surrounded in their London townhouse by European paintings, Chinoiserie and unpaid bills, and both show signs of their extramarital affairs the night before [p.49]. Typically drawing upon contemporary references – in this case the anxieties around modern marriages – Hogarth showed the perils of money and status as motivations: by the end of the series, the earl has been stabbed in a duel, the countess has poisoned herself after discovering her lover has been hanged, and their child is left orphaned and already displaying symptoms of congenital syphilis.

Hogarth's ability to work across high and low culture is perhaps most evident in his turn to popular prints soon after the refinement of *Marriage A-la-Mode*. These far more didactic prints responded to the growing sense of crisis in the city and the fears of social chaos rippling just below the surface as the urban population expanded and, with it, social inequality increased.[27] In *Gin Lane* [p.59] Hogarth added his might to the campaign to curb the gin craze which was particularly rife among the London poor,[28] depicting the spirit's grim effects: an addled mother carelessly sends her baby to its death, riots break out, and the crumbling buildings stand in for social collapse. It is a scene in stark contrast to its pair, the idealised, patriotic vision of health and prosperity portrayed in *Beer Street* [p.58]. Also published in 1751, *The Four Stages of Cruelty* [pp.60–3] extends this unsettling image of the city's brutality, portraying the escalating violence of Tom Nero, from cruelty to animals as a child to murder and robbery as an adult, and comes full circle with the barbaric treatment of his corpse in the final scene. The harsh subject matter of these prints is partly reflected in their dramatic stylistic treatment, with Hogarth asserting that 'the passions may be more forcibly expressed by a strong bold stroke' – but it was also a deliberate effort to make them cheaper, accessible and legible to 'men of the lowest rank'.[29]

Taking a new direction yet again, in 1753 Hogarth published his aesthetic theories in *The Analysis of Beauty*. This was not his first venture in this direction: his *Characters and Caricaturas* (the subscription ticket [p.47] received by those paying for a copy of *Marriage A-la-Mode* in advance) carefully draws upon the work of the Italian old masters to demonstrate the distinction between character and caricature, responding to Henry Fielding's praise of the artist as a 'Comic History-Painter' on the grounds that Hogarth was true to nature, as opposed to the exaggerations and distortion of burlesque and caricature.[30] But *The Analysis* was his most determined effort to present himself as a serious artist and thinker. Here, he argued that the serpentine line (or 'the line of grace') was a gently curving and twisting three-dimensional line that underpinned all natural and artistic beauty.[31] This was also reflected in the two prints that accompanied the treatise: the statuary yard shows the 'line of grace' in classical sculpture [p.65], while also delighting in an undercurrent of eroticism and the opportunity to jibe at connoisseurs who are happy to buy poor copies. However, much to Hogarth's chagrin, his ideas were met with public derision – suggesting his carefully crafted and dignified self-portrait of 1758 might also have been an attempt to offset this backlash [p.8].

Hogarth responded to his critics with his most ambitious series yet, *Four Prints of an Election* [pp.66–9], which comments upon the corrupt electioneering rife among both parties at the time. But there can be little doubt that the last years of his life were overshadowed by public wrangling. Having declared that he was no longer painting, devoting himself instead to engraving, it must have been galling for Hogarth to see one of the few exceptions to this, his painting of *Sigismunda* in 1759, openly ridiculed.[32] But it was *The Times*, published in September 1762, that exposed him to the most criticism [p.71]. Revealing his political allegiance,[33] the print defended the current, unpopular Bute government, showing the opposition stoking the fire

that is, quite literally, setting the world aflame in its support of an imperialist war, the mercantile interests of which are indicated in a racist sign showing a stereotyped Native American and the profits from tobacco and sugar.[34] The journalist and politician John Wilkes was one of the most vocal critics, not only claiming the print had no 'original merit' but also attacking Hogarth's character and abilities, saying '*Gain and vanity* have steered his little light bark through life.'[35] When Wilkes was arrested in 1763 for attacking the King's speech, Hogarth took his revenge, visiting the court to sketch his portrait: the result was an image of a leering Wilkes, shown with the suggestion of devil's horns, and carrying the staff and cap of liberty, the attributes of Britannia, to signal his mockery of patriotism [p.73]. Insult was only added to injury when Hogarth advertised it as a pair with his earlier portrait of Simon Lord Lovat, the Jacobite traitor [p.72]. Unsurprisingly, the matter did not rest there, with the poet Charles Churchill joining the ensuing fray, envisioning Hogarth's decline with 'The Murd'rous Pencil in his palsied Hand'.[36]

As Wilkes said himself, 'We all titter the instant he takes up a *pen*, but we tremble when we see the *pencil* in his hand'.[37] Hogarth's powers as a graphic artist were clearly undiminished. It seems apt, then, that in the last year of his life Hogarth turned once more to print to express himself. Published in April 1764, and intended as the tailpiece to the bound collections of his prints, *The Bathos* was Hogarth's final print before his death on 26 October [p.75].[38] The figure of Time, slumped beside a cracked palette and clutching a burning copy of *The Times*, is frequently interpreted autobiographically as standing in for Hogarth's own creative exhaustion, sense of isolation and despair at the attacks upon his work, perhaps even for his own sense of impending mortality. Yet, characteristically – and as the title suggests in alluding to the anticlimactic move from the grandiose to the ordinary – it still manages to take a swipe at the new fashion for the sublime in art.[39]

PLATES

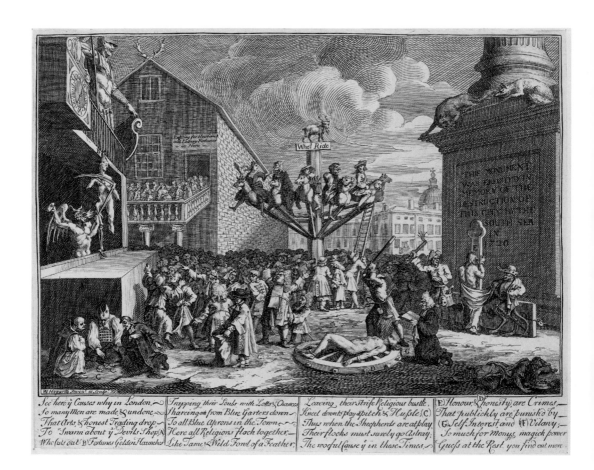

The South Sea Scheme c.1721

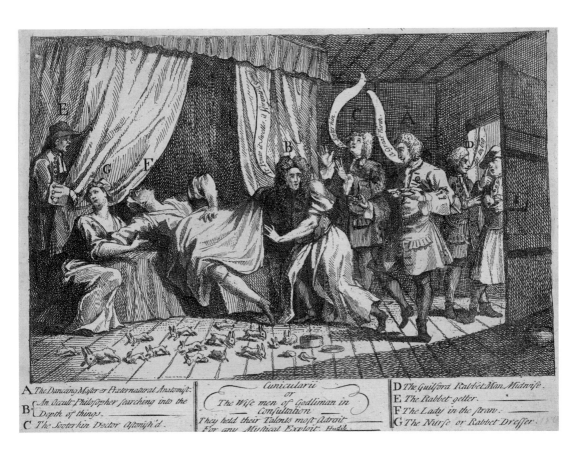

A The Dancing Master or Praeternatural Anatomist.

B { An Occult Philosopher searching into the Depth of things.

C The Sooterkin Doctor Astonish'd.

Cunicularii
or
The Wise men of Godliman in
Consultation

They held their Talents most Adroit
For any Mystical Exploit. Hudib.

D The Guilford Rabbet-Man Midwife.

E The Rabbet-getter.

F The Lady in the Straw.

G The Nurse or Rabbet-Dresser.

Cunicularii, or The Wise Men of Godliman in Consultation 1726

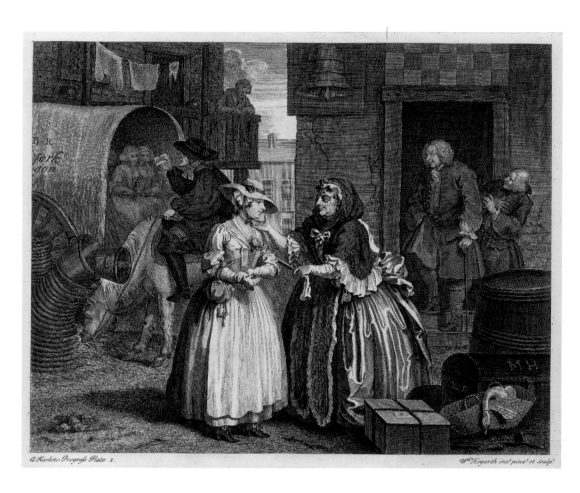

A Harlot's Progress, Plate 1 1732

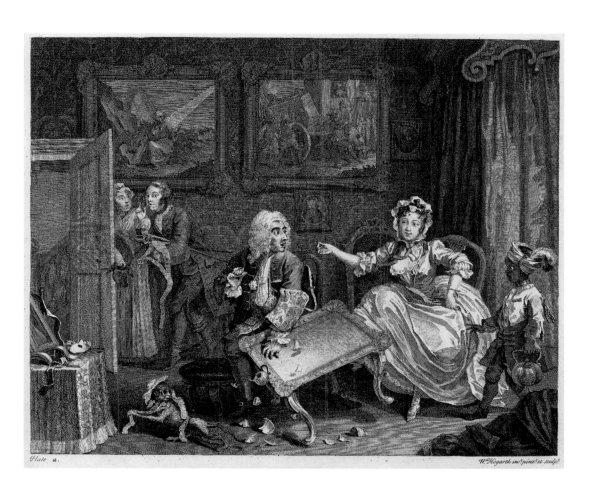

A Harlot's Progress, Plate 2 1732

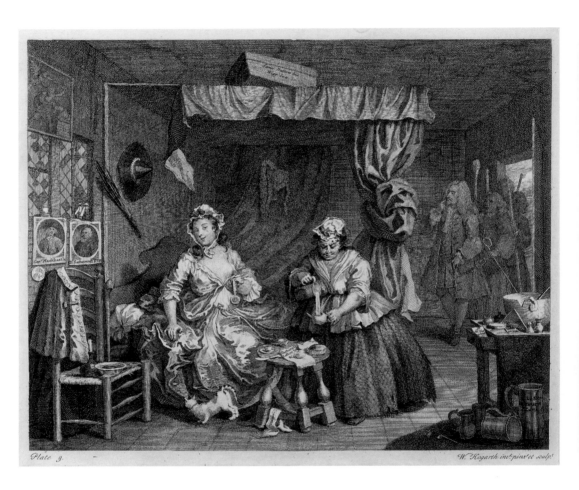

Plate 3.

A Harlot's Progress, Plate 3 1732

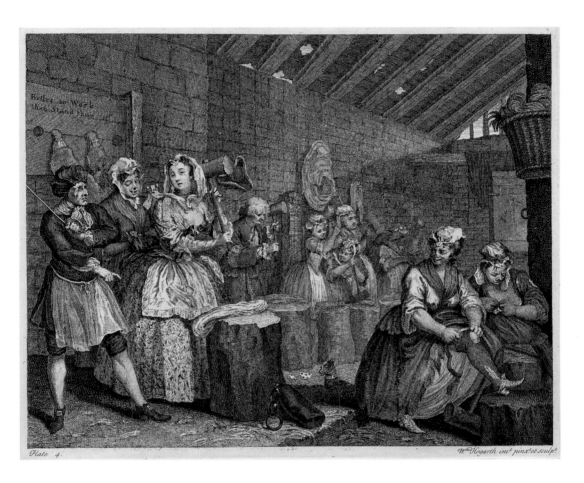

A Harlot's Progress, Plate 4 1732

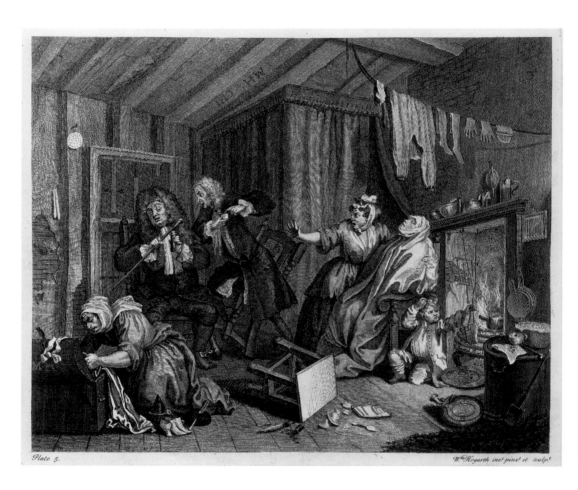

A Harlot's Progress, Plate 5 1732

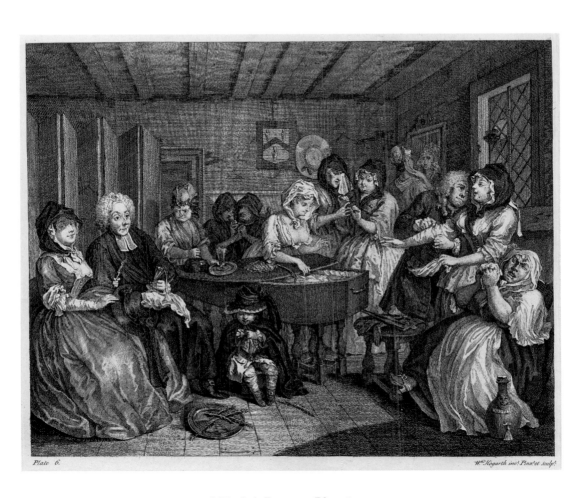

A Harlot's Progress, Plate 6 1732

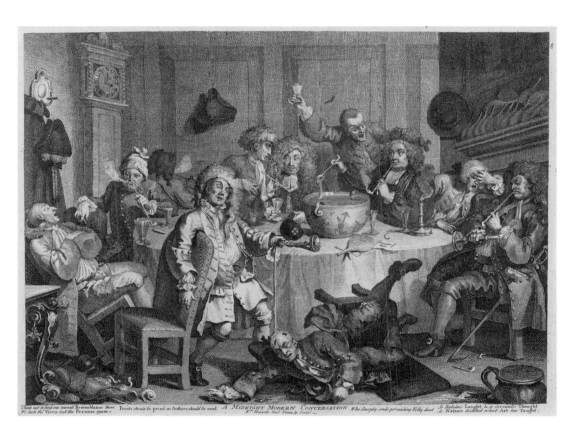

A Midnight Modern Conversation 1733

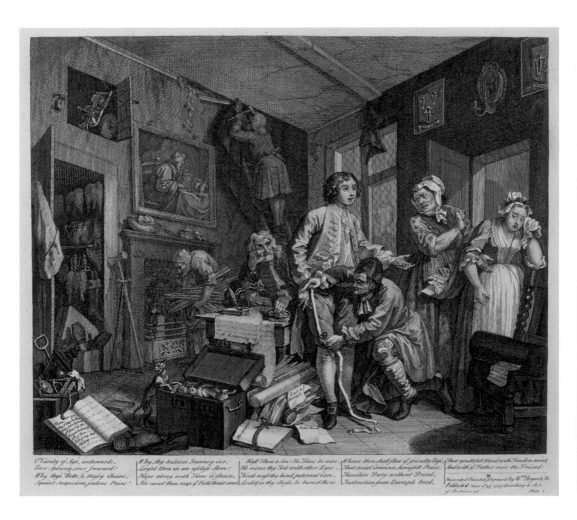

O Vanity of Age, untoward,
Ever Spleeny, ever froward!
Why these Bolts, & Massy Chains,
Squint Suspicions, jealous Pains?

Why, thy toilsom Journey o'er,
Lay'st thou in an useless Store?
Hope along with Time is flown,
Nor canst thou reap y.º Field th'ou'st sown.

Hast thou a Son? In Time be wise,
He views thy Toil with other Eyes.
Needs must thy kind paternal Care,
Lock'd in thy Chests, be buried there.

Whence then shall flow y.º friendly Ease,
That social Converse, honest Peace,
Familiar Duty without Dread,
Instruction from Example bred,

That youthfull Mind with Freedom mend,
And with y.º Father mix the Friend.

Invented Painted Engrav'd by W.ᵐ Hogarth, &.
Publish'd June y.º 25 1735 according to Act
of Parliament.
Plate 1.

A Rake's Progress, Plate 1: The Heir 1735

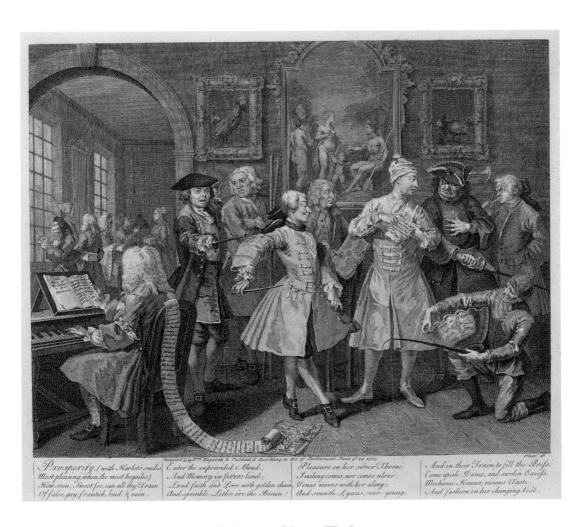

Invented & by Wm Hogarth & Publish'd & according to act of Parliament June y'e 25. 1735.

Plate 2d

Prosperity, (with Harlots smiles,
Most pleasing, when 'tis most beguiles,)
How soon, Sweet foe, can all thy Train
Of false, gay, frantick, loud & vain.

Enter the unprovided Mind;
And Memory in fetters bind;
Load faith and Love with golden chain,
And sprinkle Lethe o're the Brain!

Pleasure on her silver Throne
Smiling comes, nor comes alone;
Venus moves with her along;
And smooth Lyæus, ever-young.

And in their Train, to fill the Press,
Come apish Dance, and swoln Excess,
Mechanic Honour, vicious Taste,
And fashion in her changing Vest.

A Rake's Progress, Plate 2: The Levée 1735

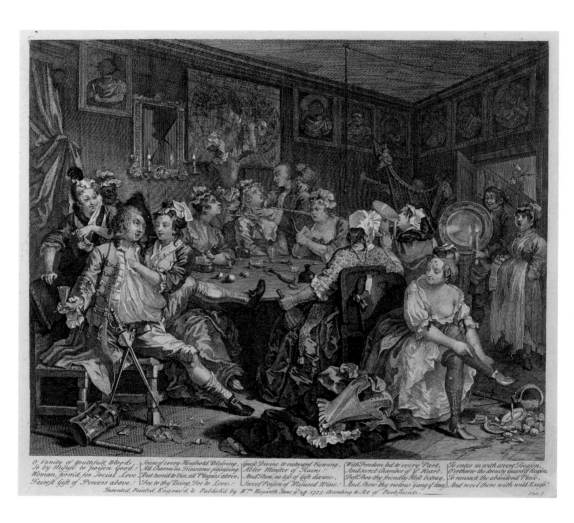

O Vanity of youthfull Bloods, | Source of every Houfhold Blefsing, | Jnclos Divine to outward Viewing, | With Freedom led to every Part, | To enter in with sweet Treason,
So by Mifuse to poison Good: | All Charms in Innocence pofsefsing, | Abler Monster of Ruin: | And secret Chamber of ye Heart; | O'erthrow the drowsy Guard of Reason,
Woman, form'd for Social Love | But turn'd to Vice, all Plagues above: | And Thou, no lefs of Gift divine, | Doft Thou thy friendly Host betray, | To ransack the abandon'd Place:
Fairest Gift of Powers above! | Foe to thy Being, Foe to Love: | Sweet Poison of Misused Wine! | And Shew thy riotous Gang of ruy, | And revel there with wild Excefs.

Invented, Painted, Engrav'd, & Publish'd by Wm. Hogarth June ye 25 1735. According to Act of Parlement. Plate 3.

A Rake's Progress, Plate 3: The Orgy 1735

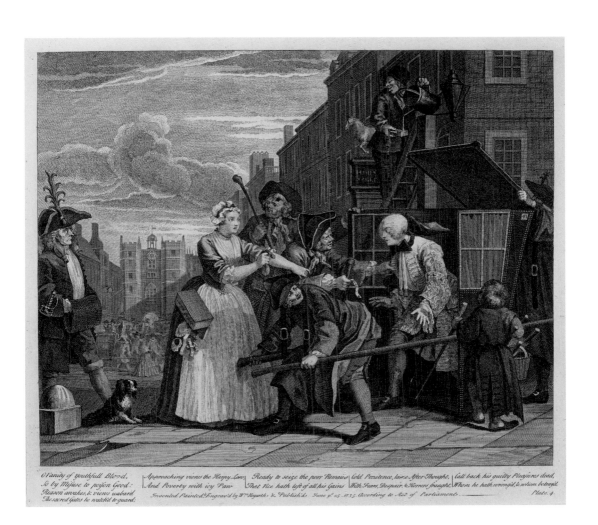

O'Vanity of youthfull Blood, | Approaching views the Happy Law | Ready to seize the poor Remains | Cold Penitence, lazie After Thought, | Call back his guilty Pleasures dead,
So by Misuse to poison Good: | And Poverty with icy Paw | That Vice hath left of all his Gains | With Fears, Despair, & Horrors fraught, | Whom he hath wrong'd, & whom betray'd.
Reason awakes, & views unbard | | | | Plate. 4.
The sacred Gates he watch'd to guard: | Invented Painted & Engrav'd by W*m* Hogarth. & Publish'd June y*e* 25. 1735. According to Act of Parliament.

A Rake's Progress, Plate 4: The Arrest 1735

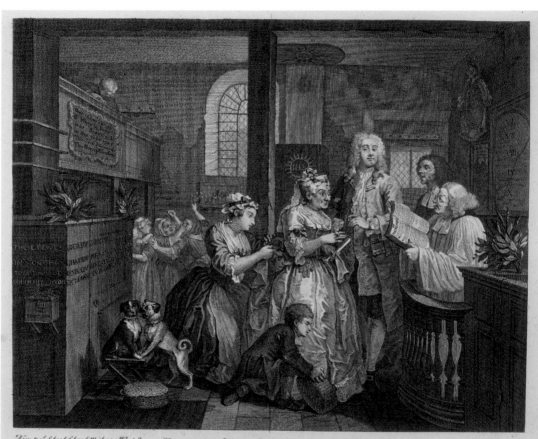

A Rake's Progress, Plate 5: The Marriage 1735

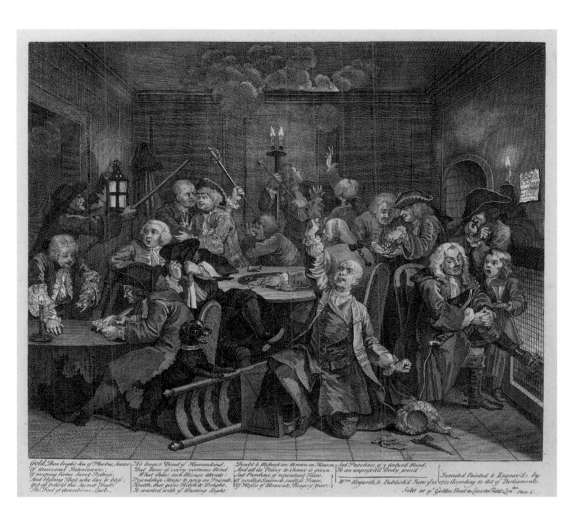

A Rake's Progress, Plate 6: The Gaming House 1735

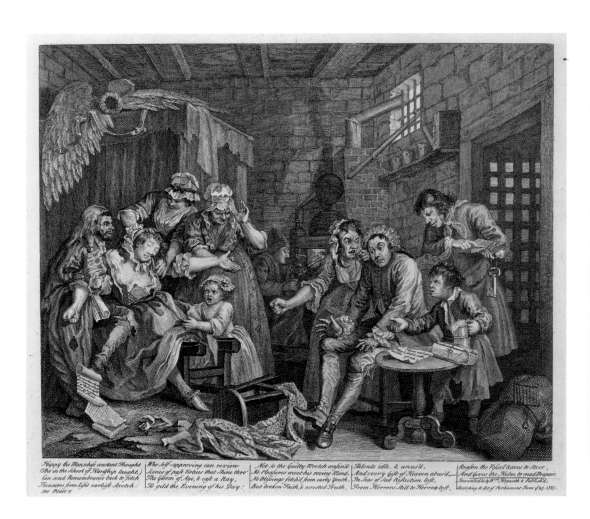

A Rake's Progress, Plate 7: The Prison 1735

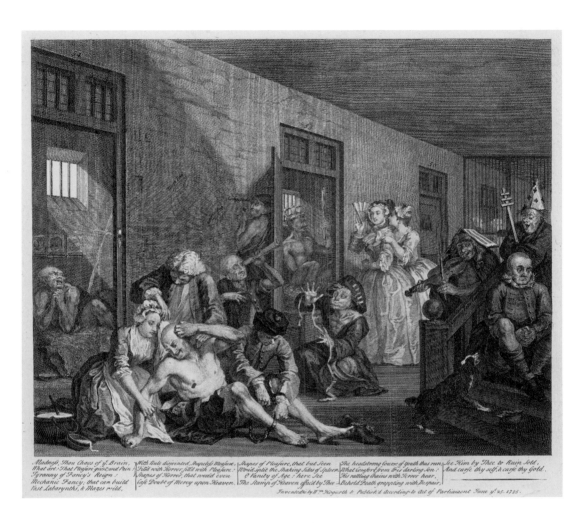

Madneſs, Thou Chaos of ye Brain,
What art: That Pleaſure givst and Pain ?
Tyranny of Fancy's Reign !
Mechanic Fancy; that can build
Vaſt Labarynths, & Mazes wild,

With aak diẜointed. Impleſs Meaſure,
Fill'd with Horror, fill'd with Pleaſure !
Shapes of Horror, that would even
caſt Doubt of Mercy upon Heaven.

Shapes of Pleaſure, that but Seen
Wou'd ẜlit the Shaking Sides of Spleen.
O Vanity of Age ! here See
The Stamp of Heaven efaic'd by Thee.

The headstrong Courſe of youth thus run
What Comfort from his darling Son :
His rattling Chains with Terror hear.
Behold Death grappling with Deſpair.

See Him by Thee. to Ruin Sold :
And curſe thy ẜelf, & curſe thy Gold .

Invented by Wm Hogarth & Publiſh'd according to Act of Parliament June yᵉ 25. 1735.

A Rake's Progress, Plate 8: The Madhouse 1735

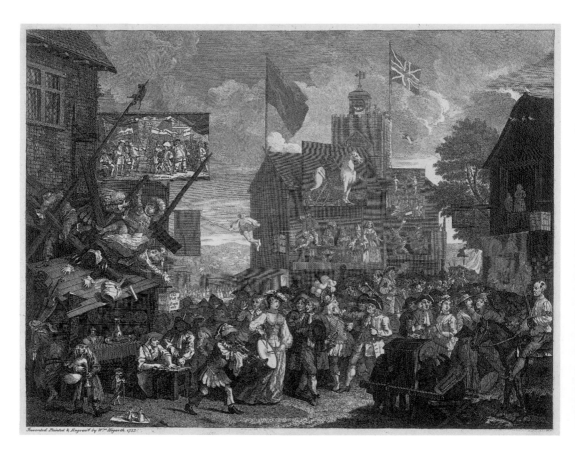

Southwark Fair 1733

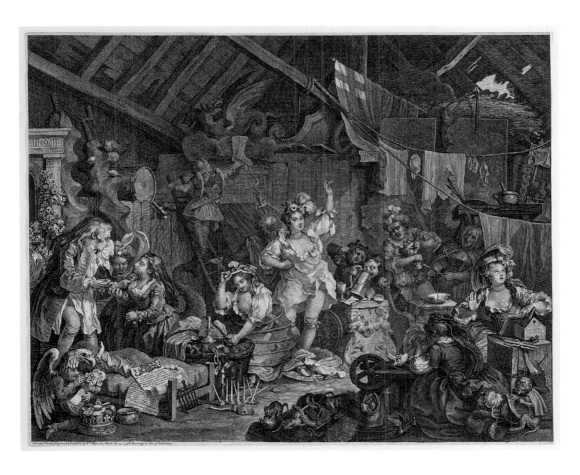

Strolling Actresses dressing in a Barn 1738

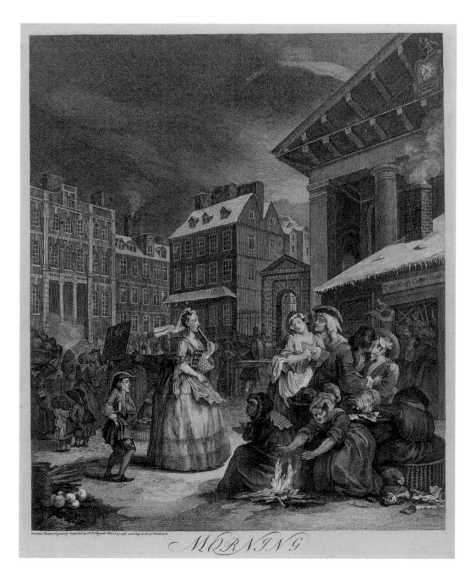

The Four Times of Day: Morning 1738

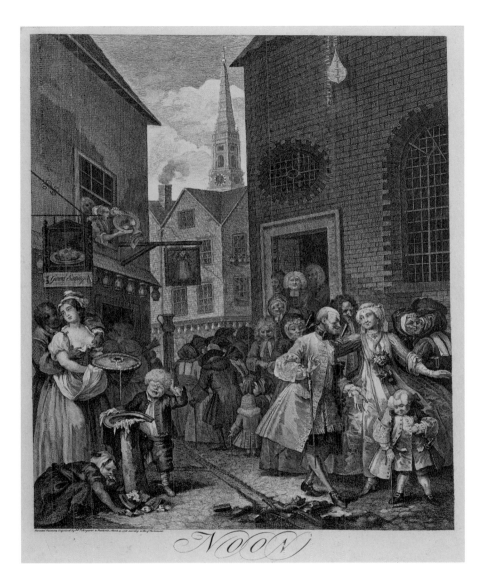

The Four Times of Day: Noon 1738

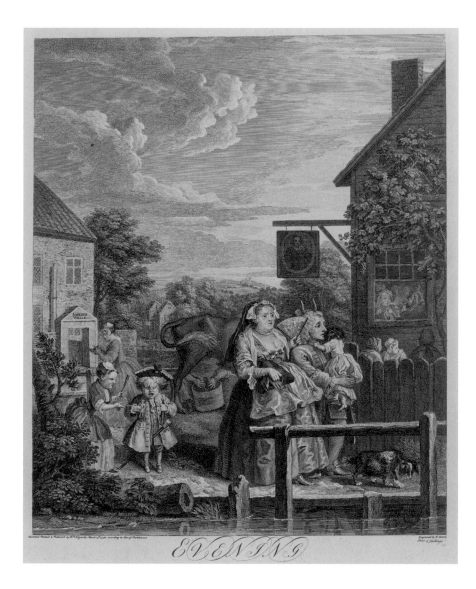

The Four Times of Day: Evening 1738

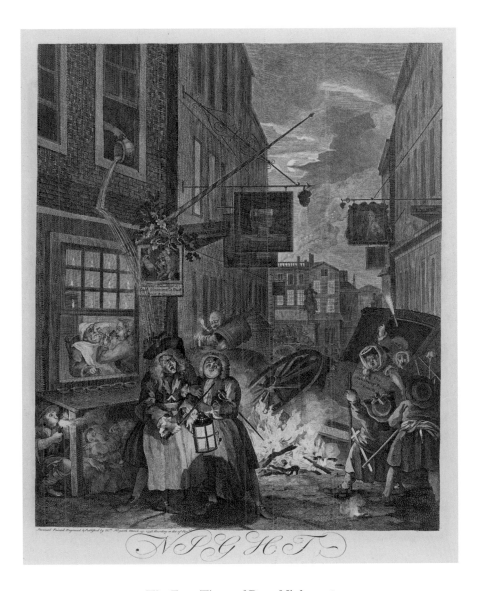

The Four Times of Day: Night 1738

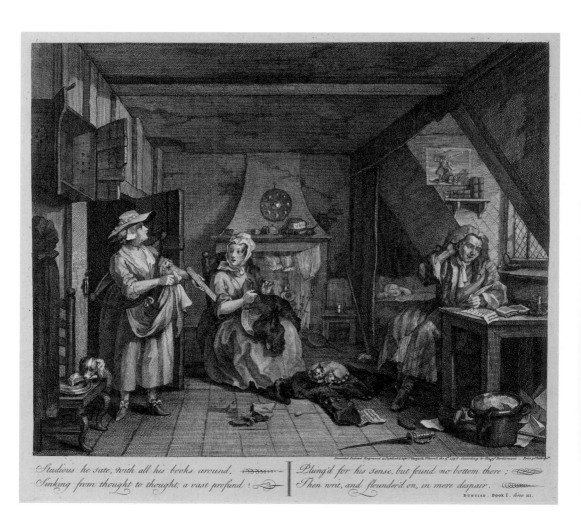

Studious he sate, with all his books around, ‖ *Plung'd for his sense, but found no bottom there;*
Sinking from thought to thought, a vast profund! ‖ *Then writ, and flounder'd on, in mere despair.*

DUNCIAD . Book I . *line* III.

The Distrest Poet 1737

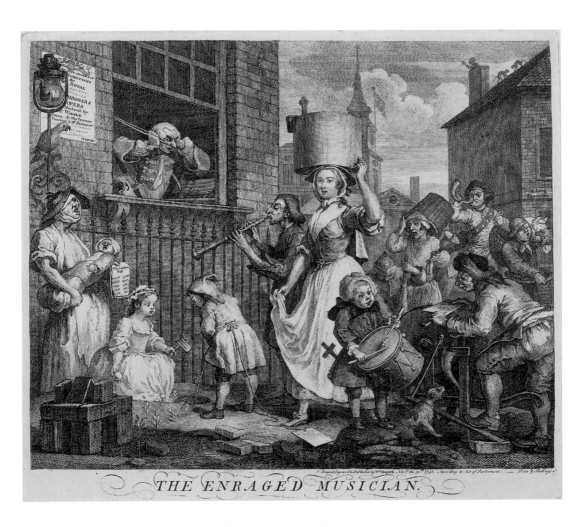

THE ENRAGED MUSICIAN.

The Enraged Musician 1741

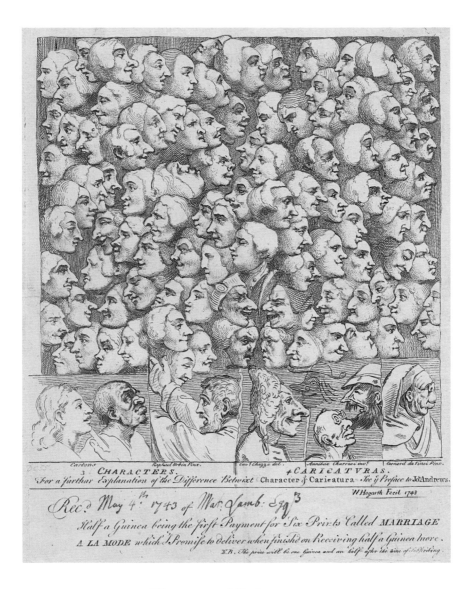

Characters and Caricaturas 1743

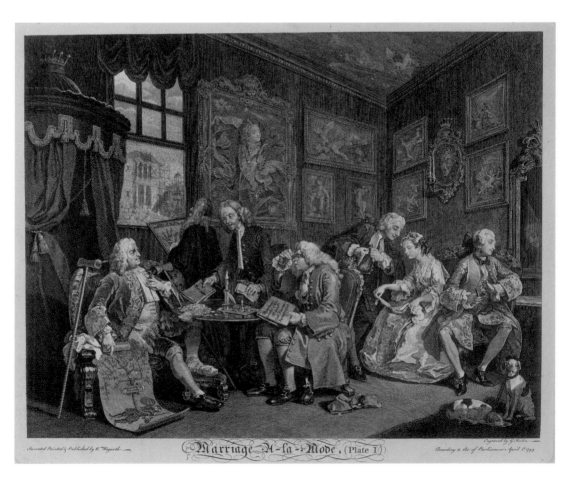

Marriage A-la-Mode, Plate I: The Marriage Settlement 1745

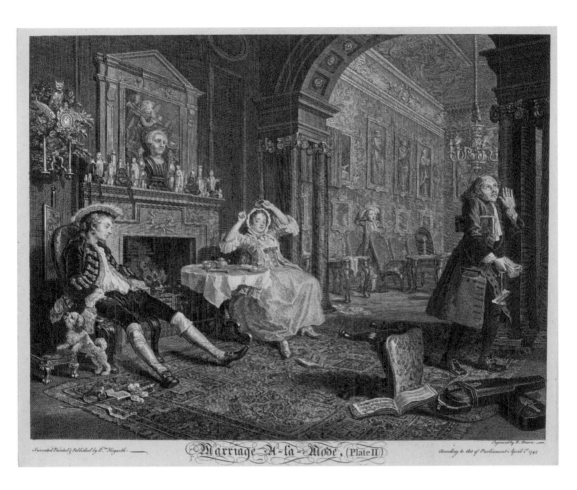

Marriage A-la-Mode, Plate II: The Tête à Tête 1745

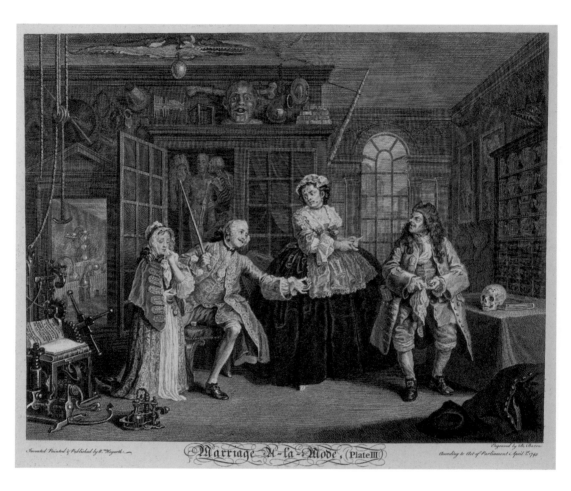

Marriage A-la-Mode, Plate III: The Inspection 1745

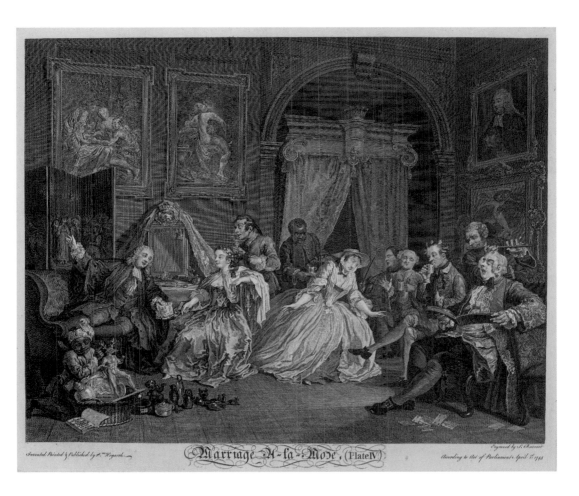

Marriage A-la-Mode, Plate IV: The Toilette 1745

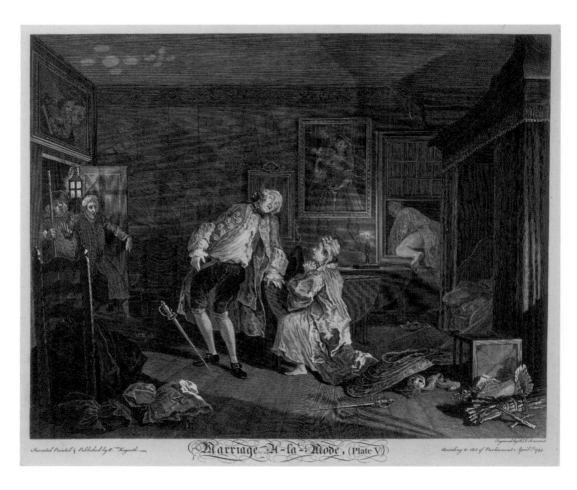

Invented Painted & Published by W. Hogarth — Marriage A-la-Mode, (Plate V) According to Act of Parliament. April 1. 1745

Marriage A-la-Mode, Plate V: The Bagnio 1745

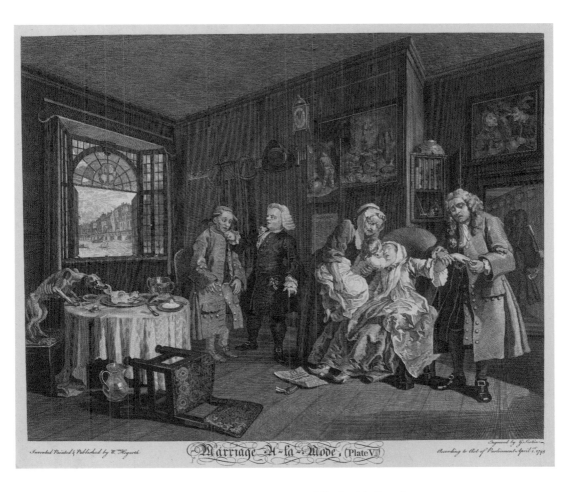

Marriage A~la~Mode. (Plate V)

Marriage A-la-Mode, Plate VI: The Lady's Death 1745

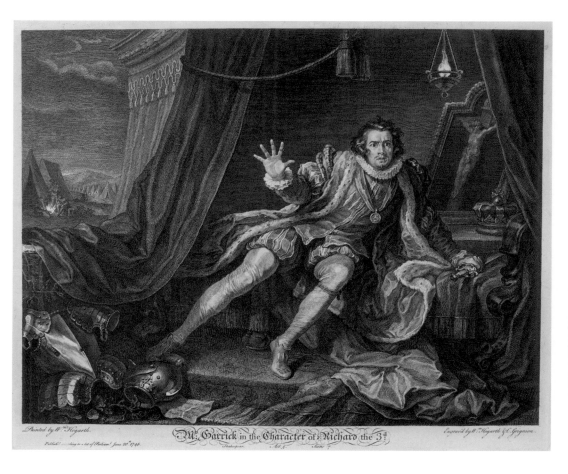

Within the engraving:

Painted by W.^m Hogarth.

M.^r Garrick in the Character of Richard the 3.^d
Shakespear. Act 5. Scene 7.

Engrav'd by W.^m Hogarth & C. Grignion.

Publish'd according to Act of Parliam.^t June 20.th 1746.

Garrick in the Character of Richard III 1746

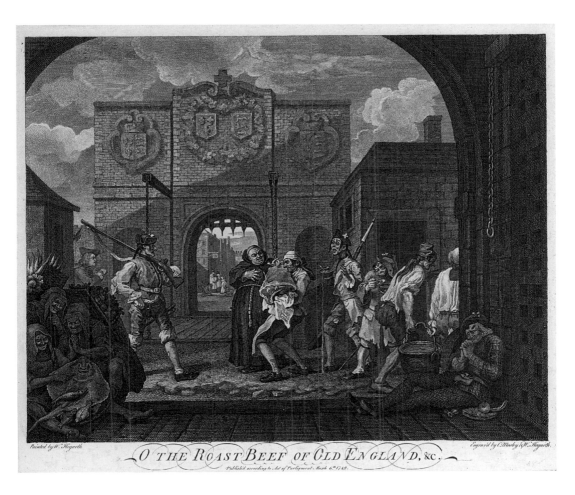

O the Roast Beef of Old England ('The Gate of Calais') 1749

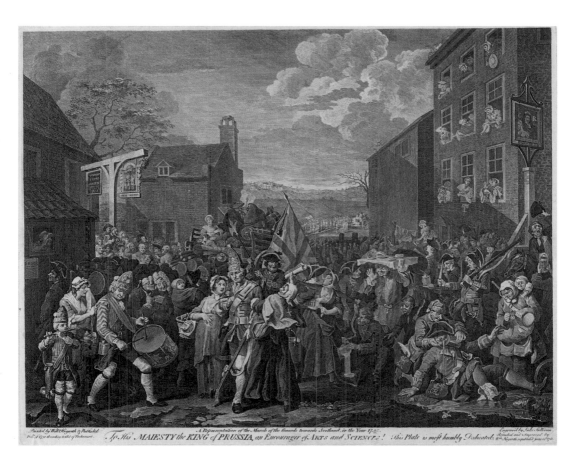

The March to Finckley 1750

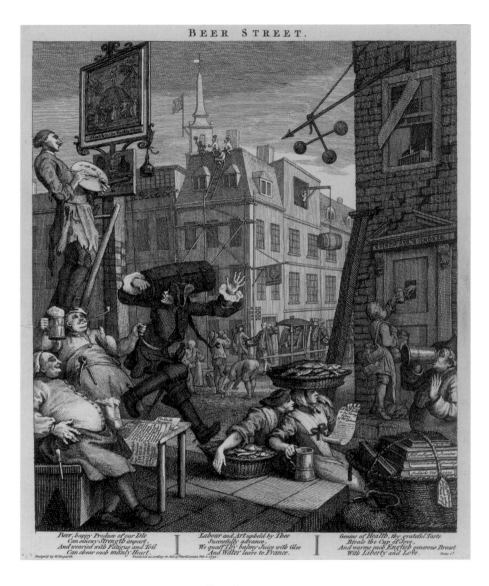

Beer Street 1751

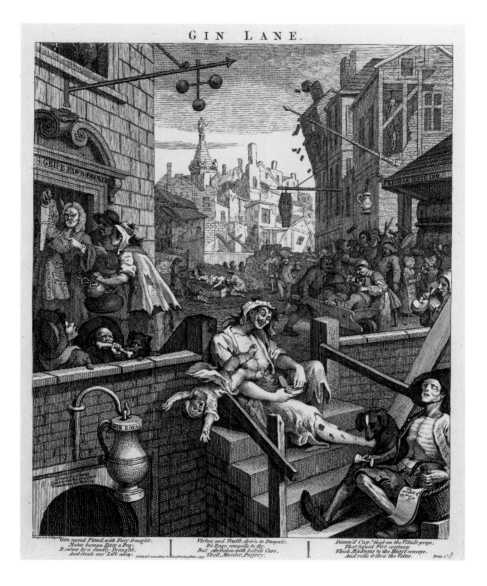

Gin Lane 1751

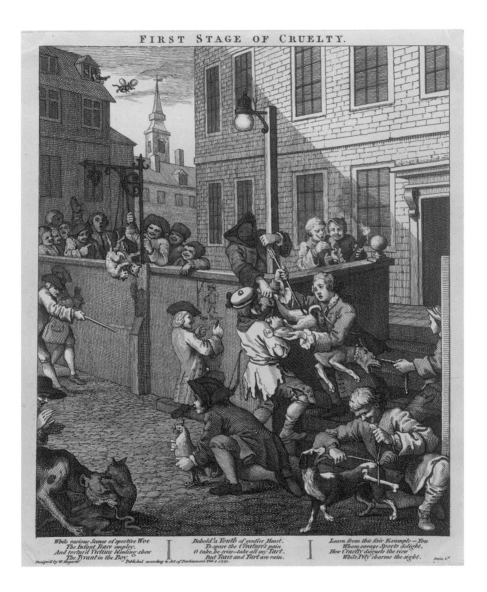

FIRST STAGE OF CRUELTY.

While various Scenes of sportive Woe
The Infant Race employ,
And tortur'd Victims bleeding shew
The Tyrant in the Boy.
Design'd by W. Hogarth

Behold! a Youth of gentler Heart,
To spare the Creature's pain,
O take, he cries—take all my Tart,
But Tears and Tart are vain.
Published according to Act of Parliament Feb. 1. 1751.

Learn from this fair Example—You
Whom savage Sports delight,
How Cruelty disgusts the view,
While Pity charms the sight.
Price 1.

First Stage of Cruelty 1751

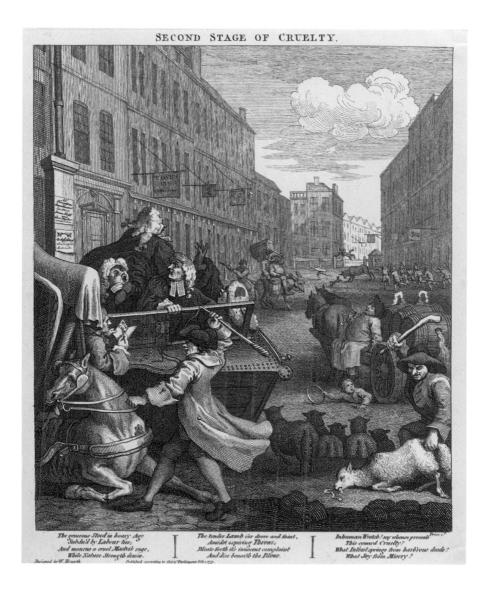

SECOND STAGE OF CRUELTY.

Second Stage of Cruelty 1751

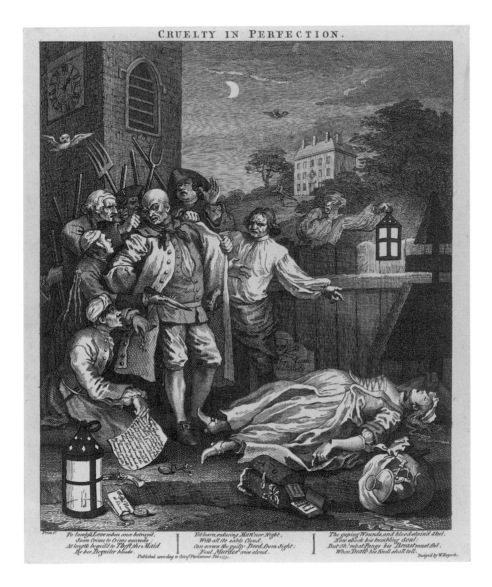

Cruelty in Perfection 1751

The Reward of Cruelty 1751

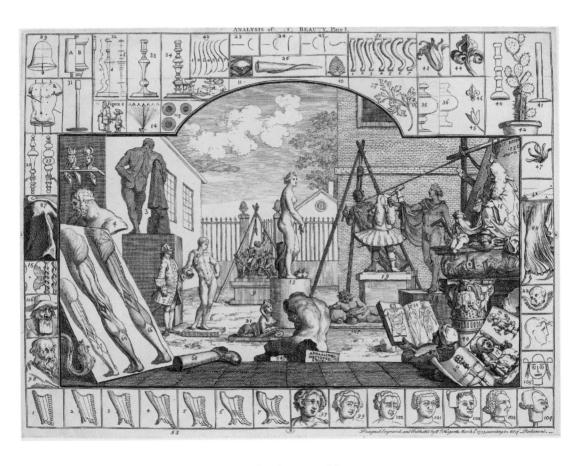

The Analysis of Beauty, Plate 1 1753

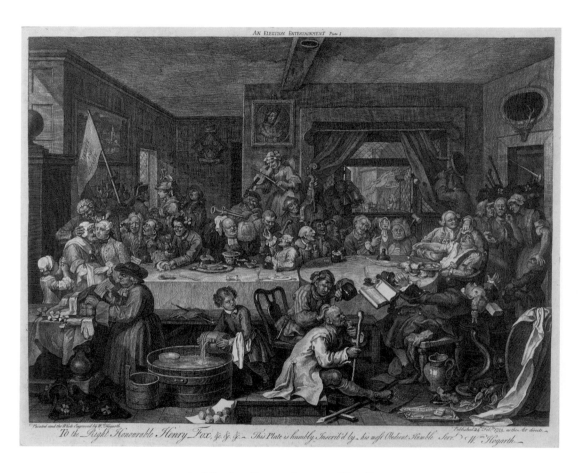

An Election Entertainment, Plate I 1755

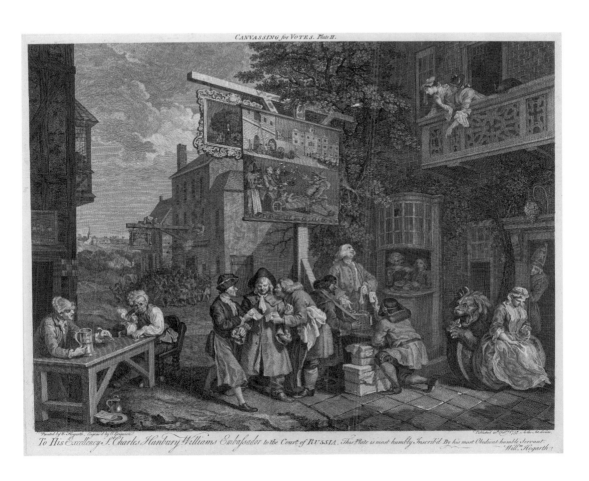

To His Excellency S.ʳ Charles Hanbury Williams Embassador to the Court of RUSSIA. This Plate is most humbly Inscrib'd By his most Obedient humble Servant. Will.ᵐ Hogarth

Canvassing for Votes, Plate II 1757

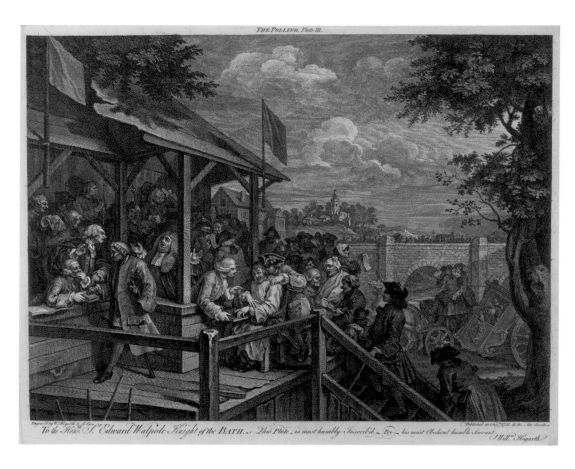

The Polling, Plate III 1758

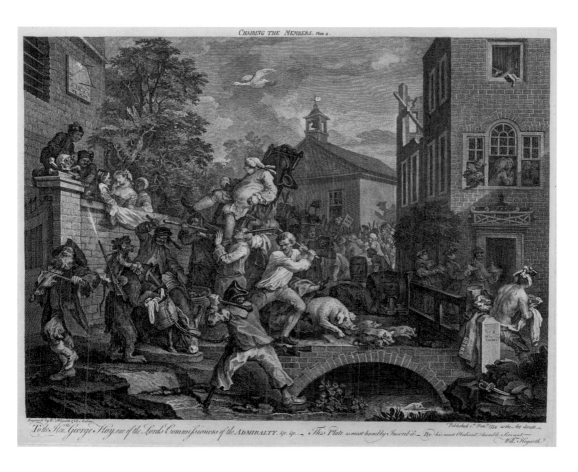

Chairing the Members, Plate IV 1758

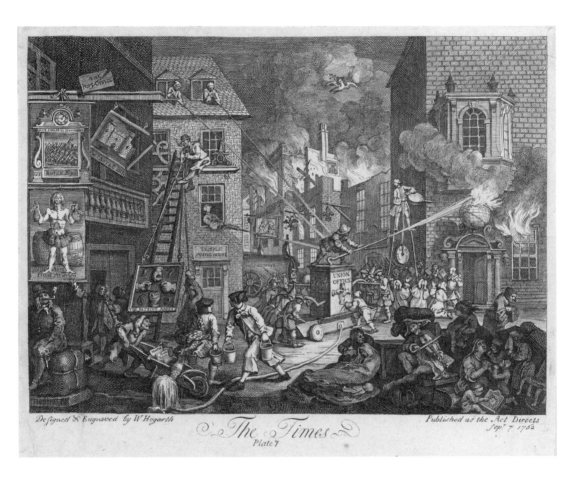

The Times, Plate 1 1762

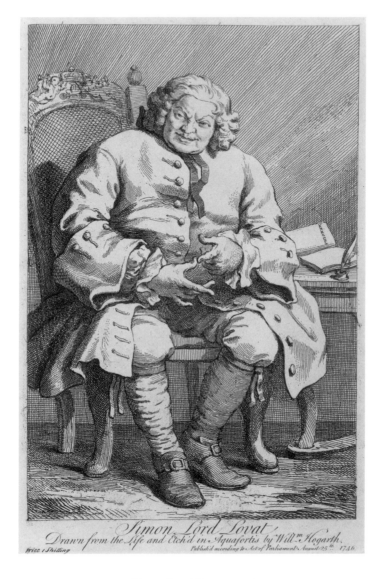

Simon Lord Lovat 1746

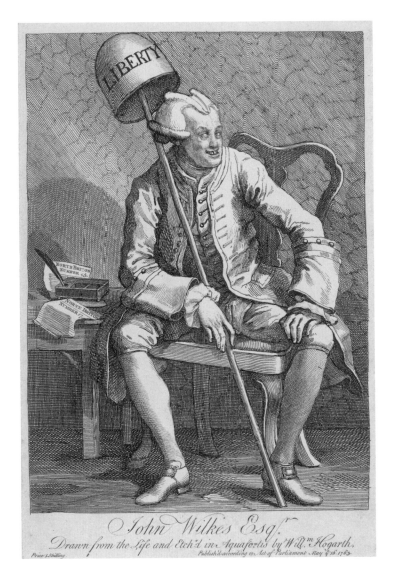

John Wilkes Esq. 1763

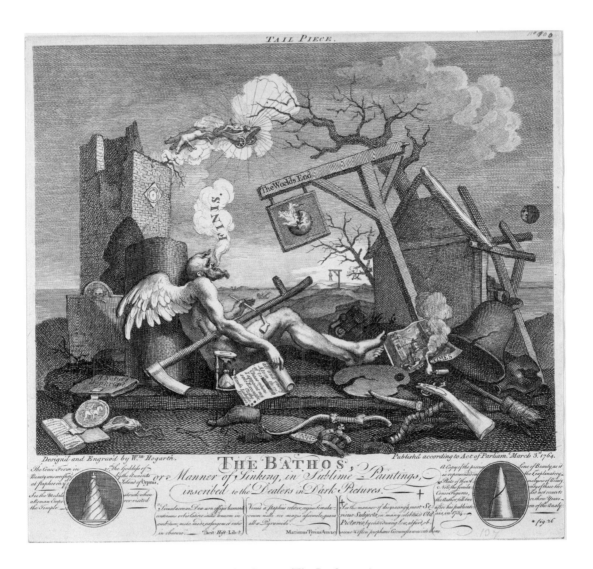

Tail Piece or *The Bathos* 1764

Notes

1 Arthur Murphy, *The Works of Henry Fielding, Esq. with an Essay on his Life and Genius*, new edn, 10 vols, London 1806, vol.5, p.13.

2 Ronald Paulson, *Hogarth's Graphic Works*, 3rd revised edn, London 1989, pp.19–20. Standard volumes already compiled could be bought, or in some instances deluxe editions were compiled under the artist's supervision (some of the surviving volumes have variations that likely reflect the tastes of the collector). The popularity of the bound volumes continued after Hogarth's death, when they were available from his wife, Jane, to whom he had left all his copperplates.

3 *Anecdotes of William Hogarth: With essays on his life and genius, and criticisms on his works, selected from Walpole, Gilpin, J. Ireland, Lamb, Phillips, and Others*, ed. John Bowyer Nichols, London 1833, p.51.

4 Paulson 1989, p.19.

5 Hogarth would later fully articulate his ideas in his book *The Analysis of Beauty* (1753).

6 Hogarth painted the self-portrait between 1757 and 1758, publishing the print in March 1758. He continued to alter the copperplate until the last year of his life, producing seven different states of the print in total. These show changes to the title and to Hogarth's face – especially the mouth: his smile disappears in the later prints – and to the figure of comedy and the mask, which is latterly given the horns of a satyr.

7 RuthAnn McNamara, 'Hogarth and the Comic Muse', *Print Quarterly*, vol.13, no.3, Sept. 1996, pp.254–5.

8 *Anecdotes of William Hogarth*, p.1.

9 The saturated print market in eighteenth-century London is discussed in Mark Hallett, *Hogarth*, London 2000, p.11–13.

10 John Nichols, *Biographical Anecdotes of William Hogarth; with a catalogue of his works chronologically arranged; and occasional remarks*, 3rd edn, enlarged and corrected, London 1785, p.27.

11 George Vertue quoted in Jenny Uglow, *Hogarth: A Life and a World*, London 1997, p.158.

12 See Paulson 1989, p.76. In his notebooks, Vertue records that in 1730 Hogarth began working on a painting of a pretty harlot, in a state of undress, getting up to take breakfast in her room at Drury Lane (the third scene), and that its popularity prompted him to paint a pair, which sparked his imagination to extend the narrative in additional scenes. The painted series was destroyed in a fire at Fonthill Gifford in Wiltshire in 1755.

13 *Anecdotes of William Hogarth*, p.8.

14 See Paulson 1989, pp.76–83.

15 *Anecdotes of William Hogarth*, pp.5, 11.

16 As with most of his complex prints, Hogarth planned and worked out the series on canvas, beginning the paintings for *A Rake's Progress* in 1733 and completing them the following year, but waiting to publish the prints until the Copyright Act came into effect.

17 See Christine Riding, 'Street Life', in *Hogarth*, exh. cat., Tate, London 2006, pp.119–21.

18 See *Hogarth and Europe*, exh. cat., Tate, London 2021, pp.13–14.

19 *The London Magazine*, no.6, 1737, p.386; quoted in Paulson 1989, p.5.

20 Paulson 1989, p.1.

21 The Venetian painter Jacopo Amigoni was initially a forerunner for the commission, until Hogarth undercut him. The two paintings for the staircase, *The Pool of Bethesda* and *The Good Samaritan*, were completed and installed in 1736 and 1737.

22 Hallett 2000, pp.148–58. Hogarth donated his grand portrait of the hospital's founder, Thomas Coram, in 1740, and participated in – and probably inaugurated – the decorative project for the court room in 1746.

23 *Anecdotes of William Hogarth*, p.9.

24 'Advertisements and Notices', *London Daily Post and General Advertiser*, 16 May 1743. The paintings of *Marriage A-la-Mode* were begun in 1743 and displayed in Hogarth's showroom until the engravings were finally published in 1745.

25 Hogarth travelled to Paris in 1743 to engage engravers for the project, securing Bernard Baron, Simon Ravenet and Gerard Scotin to engrave two plates each.

26 Hallett 2000, p.181.

27 Ibid., p.231–3.

28 *Hogarth*, exh. cat., Tate, London 2006, p.190–2.

29 *Anecdotes of William Hogarth*, pp.64–5. In a further attempt to make these prints accessible, Hogarth also employed John Bell to copy his designs as woodcut prints (p.63), but this only extended to *Cruelty in Perfection* and *The Reward of Cruelty* being published.

30 Murphy 1806, pp.11–13.

31 William Hogarth, *The Analysis of Beauty*, New York 2015, pp.71–5; Hallett 2000, pp.244–5.

32 *Anecdotes of William Hogarth*, pp.51–7.

33 As David Bindman has highlighted, far from being the radical man-of-the-people he is often figured as, Hogarth was concerned with maintaining the social status quo, supporting the government in later life and coveting the position of Serjeant Painter to the King. See David Bindman, 'Hogarth: The People's Artist?', *Hogarth: Place and Progress*, exh. cat., Sir John Soane's Museum 2020, pp.25–33.

34 Paulson 1989, pp.179–80.

35 John Wilkes, *The North Briton*, no.17, 25 September 1762, p.52; this quote also indicates that Hogarth's relationship to a pug was in currency even during his lifetime.

36 Charles Churchill, 'Epistle to Hogarth', *St James's Chronicle or the British Evening Post*, 30 June – 2 July 1763.

37 Wilkes 1762, p.51.

38 In the last year of his life, Hogarth began organising a definitive volume of his prints, to be accompanied by his autobiography, but this was left unfinished at his death.

39 Paulson 1989, p.185; Hallett 2000, pp.315–16.

Illustrated works

Measurements are in centimetres, height before width.
All works were engraved by Hogarth unless stated otherwise.

p.4
Gulielmus Hogarth 1749
Etching and engraving
40.3 × 27.9
Yale Center for British Art, Yale Art Gallery Collection

p.8
Hogarth painting the comic muse 1758
or *Wm. Hogarth Serjeant Painter to His Majesty*
Etching and engraving
40.2 × 35.3
Andrew Edmunds

p.20
The South Sea Scheme c.1721
Etching and engraving
25.8 × 32.5
National Gallery of Art, Washington

p.21
Cunicularii, or The Wise Men of Godliman in Consultation 1726
Etching and engraving
18.8 × 24.9
The Metropolitan Museum of Art, New York

pp.22–7
A Harlot's Progress 1732
Plates 1–6
Etching with engraving
Each 32 × 38
Andrew Edmunds

p.29
A Midnight Modern Conversation 1733
Etching and engraving
34.5 × 47
Andrew Edmunds

pp.30–7
A Rake's Progress 1735
Plate 1: The Heir
Plate 2: The Levée
Plate 3: The Orgy
Plate 4: The Arrest
Plate 5: The Marriage
Plate 6: The Gaming House
Plate 7: The Prison
Plate 8: The Madhouse
Etching with engraving
Each approx. 35.5 × 41
Andrew Edmunds

p.38
Southwark Fair 1733
(published 1734)
Engraving
46.4 × 62.9
Yale Center for British Art, Gift of Mrs Lyall Dean, Mrs Borden Helmer, and the Estate of Bliss Reed Crocker in memory of Mr and Mrs Edward Bliss Reed, transfer from the Yale University Art Gallery

p.39
Strolling Actresses dressing in a Barn 1738
Etching and engraving
40.3 × 57
The Metropolitan Museum of Art, New York. Harris Brisbane Dick Fund, 1932

pp.40–3
The Four Times of Day 1738

p.40
Morning 1738
Etching and engraving
48.7 × 39.2
Andrew Edmunds

p.41
Noon 1738
Etching and engraving
48.6 × 40.2
Andrew Edmunds

p.42
Evening 1738
Etching and engraving with B. Baron
48.8 × 40.2
Andrew Edmunds

p.43
Night 1738
Etching and engraving
48.6 × 40.2
Andrew Edmunds

p.44
The Distrest Poet 1737
Etching and engraving
35.7 × 40.8
Andrew Edmunds

p.45
The Enraged Musician 1741
Etching and engraving
39.2 × 44.9
National Gallery of Art,
Washington

p.47
Characters and Caricaturas 1743
Etching
28.3 × 24.1
Yale Center for British Art, Yale
Art Gallery Collection, Gift of
Chauncey B. Tinker, B.A. 1899

pp.48–53
Marriage A-la-Mode 1745

Plate I: The Marriage Settlement
Etching and engraving by
G. Scotin
38.1 × 46.6
Andrew Edmunds

Plate II: The Tête à Tête
Etching and engraving by
B. Baron
38.3 × 46.4
Andrew Edmunds

Plate III: The Inspection
Etching and engraving by
B. Baron
38.2 × 46.4
Andrew Edmunds

Plate IV: The Toilette
Etching and engraving by
S. Ravenet
38.2 × 46.5
Andrew Edmunds

Plate V: The Bagnio
Etching and engraving by
S. Ravenet
38.2 × 46.5
Andrew Edmunds

Plate VI: The Lady's Death
Etching and engraving by
G. Scotin
38.1 × 46.4
Andrew Edmunds

p.54
*Garrick in the Character of
Richard III* 1746
Etching and engraving by
Charles Grignion and William
Hogarth
42 × 52.6
Andrew Edmunds

p.55
*O the Roast Beef of Old England
('The Gate of Calais')* 1749
Etching and engraving, with
Charles Mosley
38.2 × 46
The Metropolitan Museum of
Art, New York. Harris Brisbane
Dick Fund, 1932

p.57
The March to Finchley 1750
[also known as *The March of the
Guards to Finchley*]
Engraved by William Hogarth
and Luke Sullivan
Engraving
41.3 × 54.3
Yale Center for British Art, Paul
Mellon Collection

p.58
Beer Street 1751
Etching and engraving
39 × 32.6
Andrew Edmunds

p.59
Gin Lane 1751
Etching and engraving
38 × 32.1
Andrew Edmunds

pp.60–3
The Four Stages of Cruelty 1751
Engraving
Each 39.1 × 32.4
First Stage of Cruelty
Second Stage of Cruelty
Cruelty in Perfection
Yale Center for British Art, Paul
Mellon Collection / Yale Art
Gallery Collection

The Reward of Cruelty
Woodcut by John Bell
45.2 × 37.6
National Gallery of Art,
Washington

p.65
The Analysis of Beauty, Plate 1 1753
Etching and engraving
38.2 × 50.1
National Gallery of Art,
Washington

pp.66–9
Four Prints of an Election 1755–8

p.66
Plate I: An Election Entertainment
Etching and engraving
43.3 × 55.5
Andrew Edmunds

p.67
Plate II: Canvassing for Votes
Etching and engraving by
C. Grignion
43.6 × 55.5
Andrew Edmunds

p.68
Plate III: The Polling
Etching and engraving by
William Hogarth and F.M. Le
Cave
43.7 × 55.8
Andrew Edmunds

p.69
Plate IV: Chairing the Members
Etching and engraving by
William Hogarth and F. Aveline
43.4 × 55.7
Andrew Edmunds

p.71
The Times, Plate 1 1762
Etching and engraving
25 × 30.5
The Metropolitan Museum of
Art, New York. Gift of Sarah
Lazarus, 1891

p.72
Simon Lord Lovat 1746
Etching and engraving
37.3 × 24.6
The Metropolitan Museum of
Art, New York. Gift of Sarah
Lazarus, 1891

p.73
John Wilkes Esq. 1763
Etching and engraving
39.4 × 26
Yale Center for British Art;
Yale University Art Gallery
Collection. Gift of Allen Evarts
Foster, B.A.

p.75
Tailpiece or *The Bathos* 1764
Etching and engraving
31.8 × 33.3
The Metropolitan Museum of
Art, New York. Harris Brisbane
Dick Fund, 1932

Index